100
Hybrids

Jefferson Hansen

Post-Asemic Press

Post-Asemic Press 007

ISBN-13: 978-1-7328788-5-3

Contact: postasemicpress@gmail.com
postasemicpress.blogspot.com

Cover Art by Michael Jacobson

Some of these poems appeared in *Brave New Word Magazine* and *The New Post-Literate* blog.

All asemic "symbols" in this book are original, and any resemblance to conventional symbols of any kind is purely incidental.

Jefferson Hansen's *100 Hybrids* trust themselves. Hand-drawn language and images conjoin to render fresh experiences encompassing nature ("In the night before / the sideways sun / fish flit like purple / and dart like blue"); consciousness ("The only success is guesswork"); and social reality ("This book is under surveillance"). I am captivated by the naturalness of Hansen's artistry that depicts with deep appreciation how it feels to be alive.

—Sheila E. Murphy, Author of
Reporting Live From You Know Where

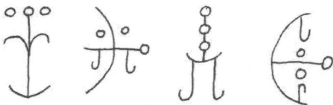

this poem is under surveillance
this poem will be "read"
by more algorithms than people
this poem was written
while Spotify "played"
Spotify has more data
on this poem than I do
can Spotify "interpret" this poem
this poem was published
in a different form on Facebook
this poem is part of my
Facebook security download
this poem was emailed to the publisher
of this Print on Demand book
yet this poem exists most securely
in the Cloud

microplastics dry the lungs
 lead surges on the heart beat
death already happened in the past
 molecules of mercury in flesh
the body might go quick
 the brain ends by thinking 1 & 2
the most powerful thought ever
 lungs brain heart hollowed
death happens in the future
 the earth has toxified insects
robots roam like brontosaurus
 they try to stretch to 3 & up
numbers where the mammals lived
 but robots cannot get there
robots program and fix themselves
 they use 1 & 2 only
there are robots everywhere
 they will realize their limits
they might be unable to overcome

in the coffeehouse
a woman's fingers
scurry over her
phone's screen
she plays a game against
artificial intelligence
a man reads a novel
inhabits a world
of someone else's making
a third person listens
to music on her phone
with earplugs
to drown out
the recordings of
alternative rock
filling the room

a way of thinking with
 riders in
busses connected to
 little supercomputers
timed by the
atomic clock
cars rolling alongside
 on a street lined
by grey and grimy snow
people on the sidewalk
 hunched in jackets
 looking at phones
this can't all add up
 to something
too many particulars
 overlaid and penetrated
the bus stops and
 cars roll past
pacemakers no doubt
 electrifying the heart
 in a few drivers

we cannot climb
 like a monkey
unless we have
 an hydraulic lift
we cannot smell
 like a dog
unless we have
 instruments
we cannot sleep
 like a winter bear
unless we are
 properly drugged
we can do
 so many things

• Super interesting.
Technology has
pulled us away
from nature

5

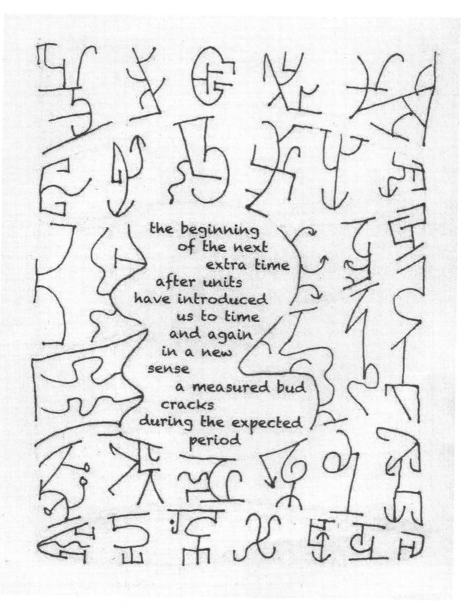

the beginning
of the next
extra time
after units
have introduced
us to time
and again
in a new
sense
a measured bud
cracks
during the expected
period

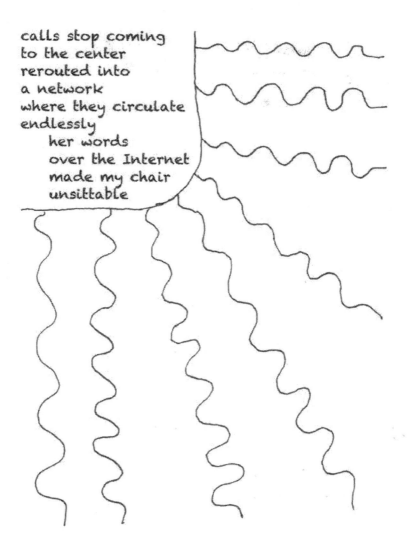

calls stop coming
to the center
rerouted into
a network
where they circulate
endlessly
 her words
 over the Internet
 made my chair
 unsittable

walking beside
a busy street
in a parody
of what our
ancestors thought
would be the
future
the sewers cannot
handle all
the melting snow
this January thaw
a man asks
for a quarter
gasoline smells
the sun
low in the
southwestern sky
blazes between
the shadows of
buildings across
the street
black water splashes
up on the sidewalk
at dusk streetlights—
lights in the
office buildings
lights everywhere
except the sky

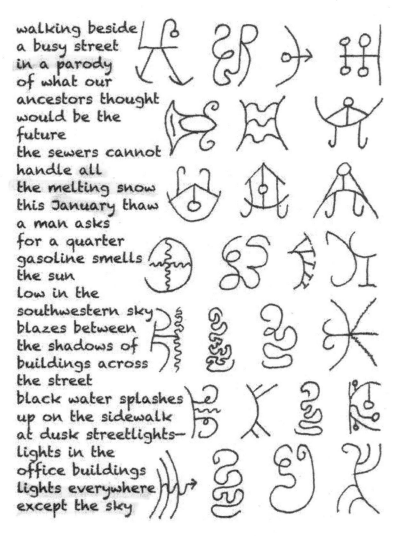

• Climate Change
• Light pollution

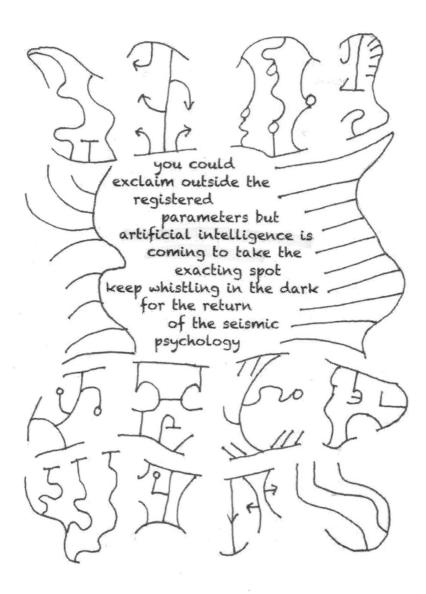

you could
exclaim outside the
registered
 parameters but
artificial intelligence is
 coming to take the
 exacting spot
keep whistling in the dark
 for the return
 of the seismic
 psychology

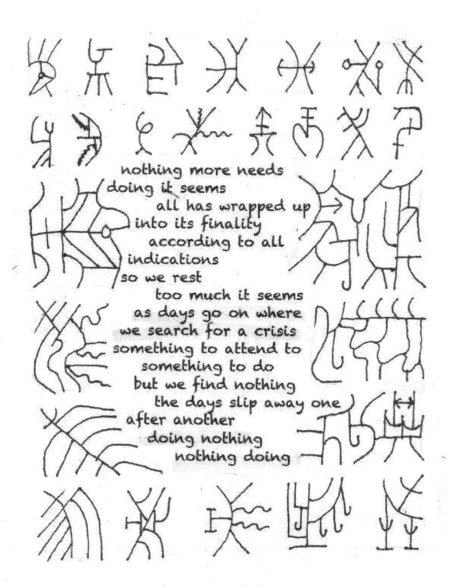

nothing more needs
doing it seems
all has wrapped up
into its finality
according to all
indications
so we rest
too much it seems
as days go on where
we search for a crisis
something to attend to
something to do
but we find nothing
the days slip away one
after another
doing nothing
nothing doing

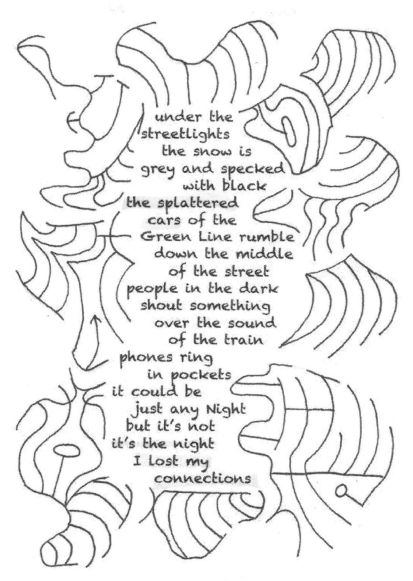

under the
streetlights
the snow is
grey and specked
with black
the splattered
cars of the
Green Line rumble
down the middle
of the street
people in the dark
shout something
over the sound
of the train
phones ring
in pockets
it could be
just any Night
but it's not
it's the night
I lost my
connections

Connections & social life
only through technology

11

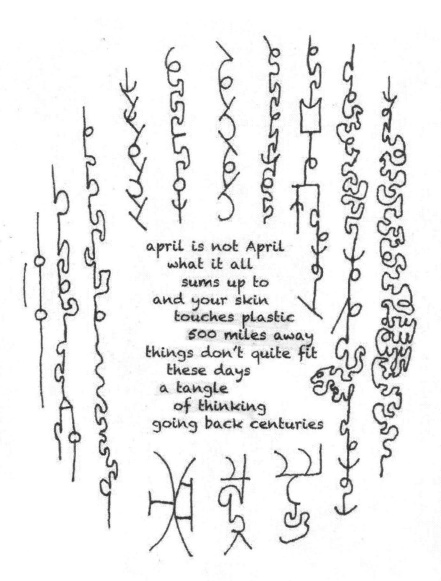

april is not April
what it all
sums up to
and your skin
touches plastic
500 miles away
things don't quite fit
these days
a tangle
of thinking
going back centuries

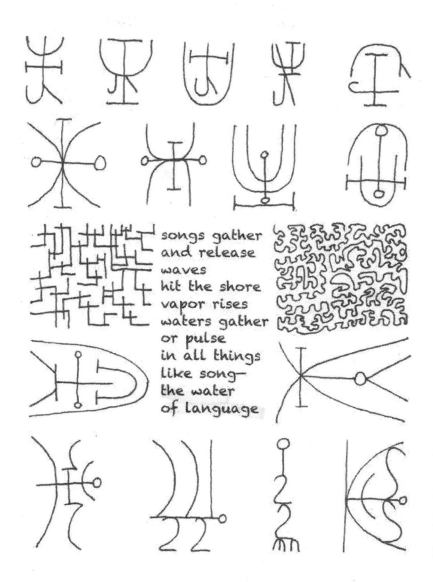

songs gather
and release
waves
hit the shore
vapor rises
waters gather
or pulse
in all things
like song—
the water
of language

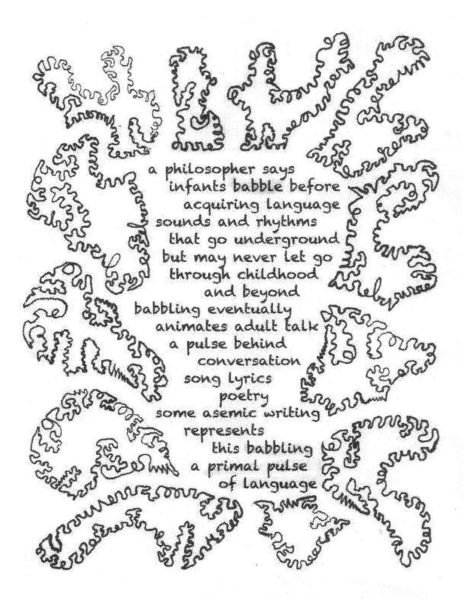

a philosopher says
infants babble before
acquiring language
sounds and rhythms
that go underground
but may never let go
through childhood
and beyond
babbling eventually
animates adult talk
a pulse behind
conversation
song lyrics
poetry
some asemic writing
represents
this babbling
a primal pulse
of language

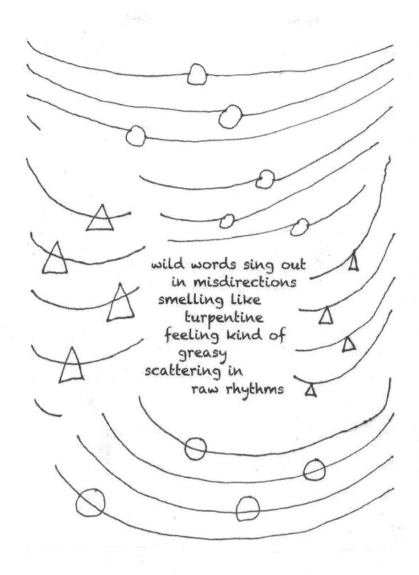

wild words sing out
in misdirections
smelling like
turpentine
feeling kind of
greasy
scattering in
raw rhythms

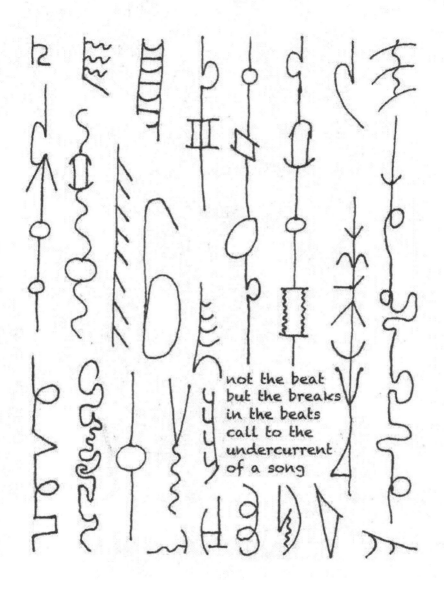

not the beat
but the breaks
in the beats
call to the
undercurrent
of a song

16

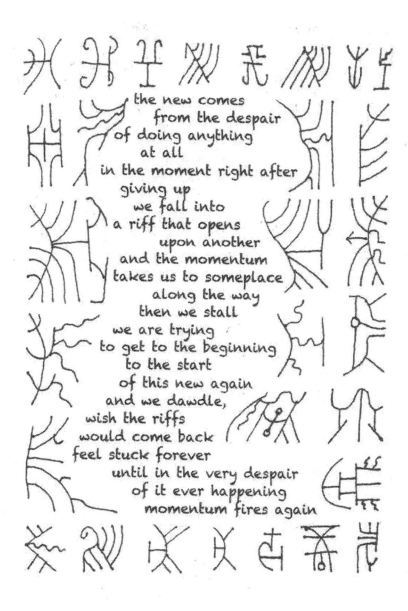

the new comes
 from the despair
of doing anything
 at all
in the moment right after
 giving up
 we fall into
a riff that opens
 upon another
and the momentum
takes us to someplace
 along the way
 then we stall
 we are trying
 to get to the beginning
 to the start
 of this new again
 and we dawdle,
 wish the riffs
 would come back
feel stuck forever
 until in the very despair
 of it ever happening
 momentum fires again

17

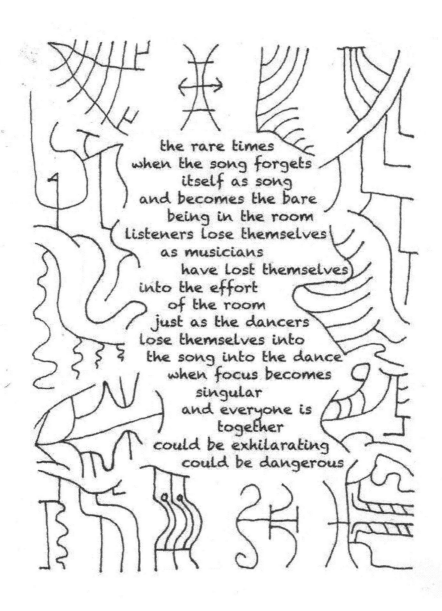

the rare times
when the song forgets
itself as song
and becomes the bare
being in the room
listeners lose themselves
as musicians
have lost themselves
into the effort
of the room
just as the dancers
lose themselves into
the song into the dance
when focus becomes
singular
and everyone is
together
could be exhilarating
could be dangerous

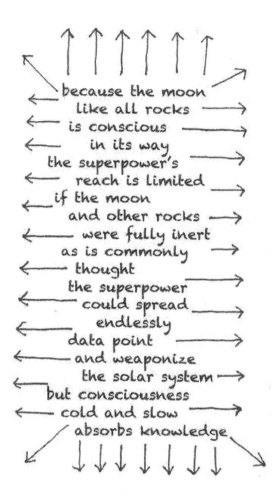

because the moon
like all rocks
is conscious
in its way
the superpower's
reach is limited
if the moon
and other rocks
were fully inert
as is commonly
thought
the superpower
could spread
endlessly
data point
and weaponize
the solar system
but consciousness
cold and slow
absorbs knowledge

beyond the city's forests
in an afternoon quiet
 that ripples outward
 to the green
 clapboard buildings
 in the distance
we walk toward them
 across grass
 not talking
as they get bigger and
more detailed
 tidy moldings
 window boxes
you tell me slowly
 "corruption is
 everywhere"

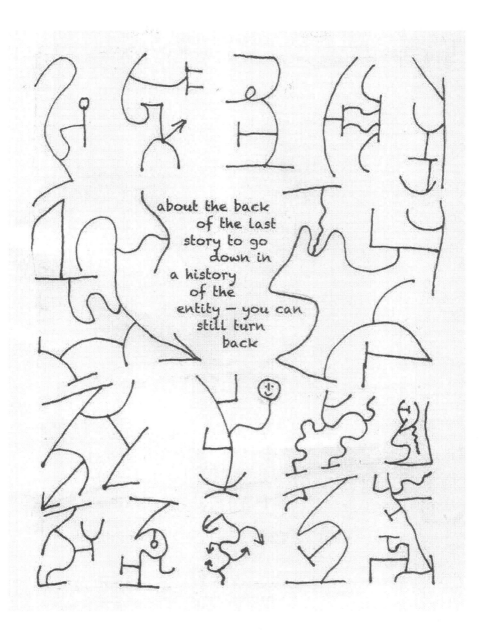

about the back
of the last
story to go
down in
a history
of the
entity — you can
still turn
back

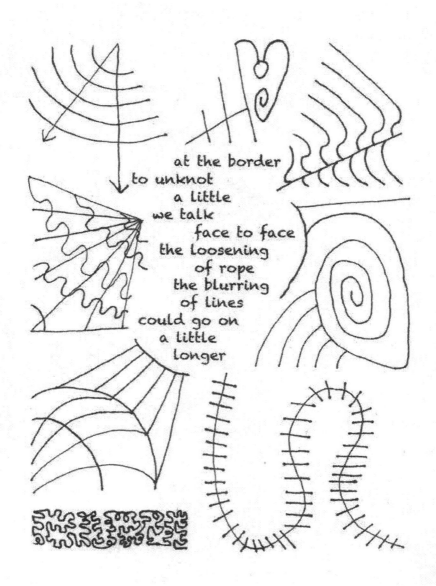

at the border
to unknot
a little
we talk
face to face
the loosening
of rope
the blurring
of lines
could go on
a little
longer

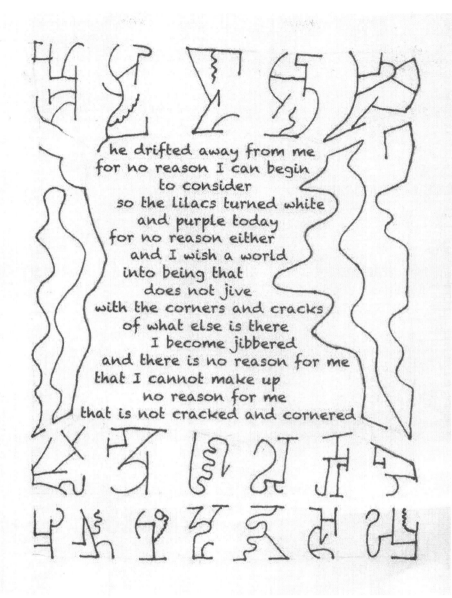

he drifted away from me
for no reason I can begin
to consider
so the lilacs turned white
and purple today
for no reason either
and I wish a world
into being that
does not jive
with the corners and cracks
of what else is there
I become jibbered
and there is no reason for me
that I cannot make up
no reason for me
that is not cracked and cornered

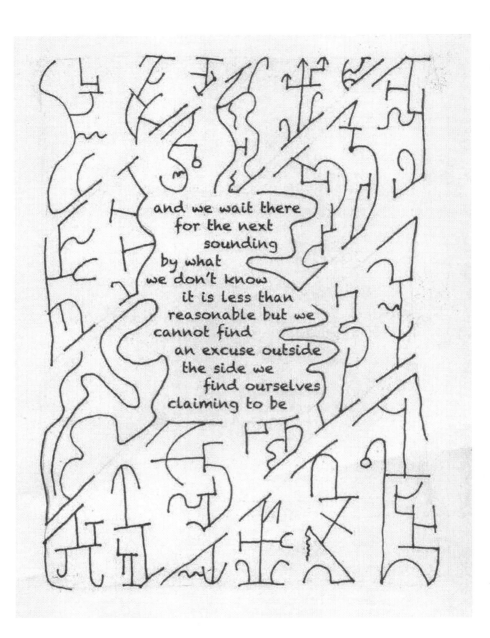

and we wait there
for the next
sounding
by what
we don't know
it is less than
reasonable but we
cannot find
an excuse outside
the side we
find ourselves
claiming to be

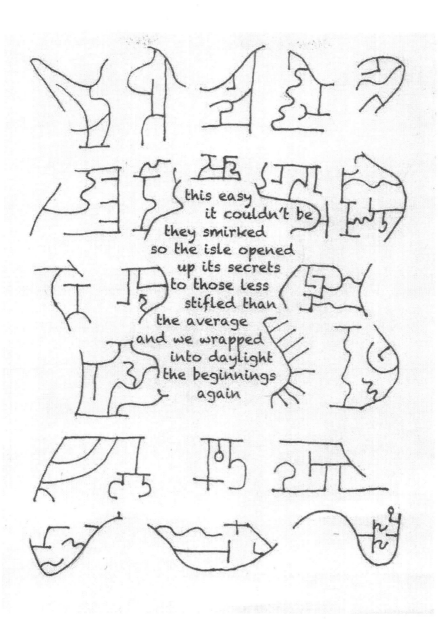

this easy
it couldn't be
they smirked
so the isle opened
up its secrets
to those less
stifled than
the average
and we wrapped
into daylight
the beginnings
again

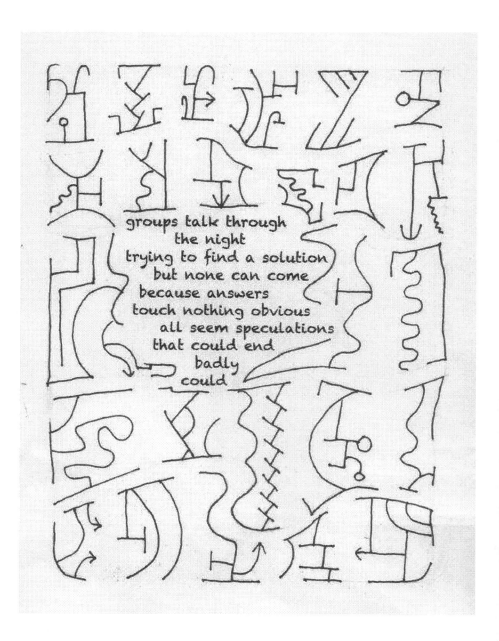

groups talk through
the night
trying to find a solution
but none can come
because answers
touch nothing obvious
all seem speculations
that could end
badly
could

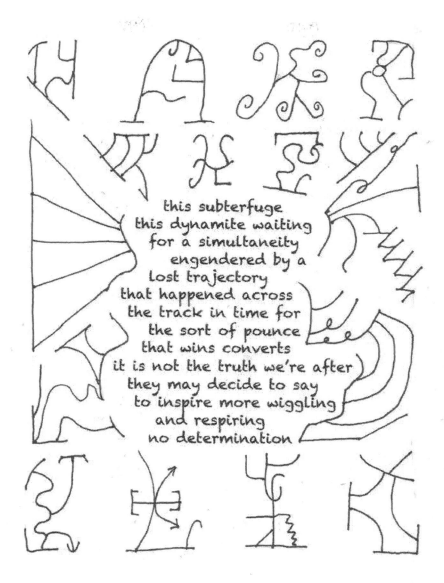

this subterfuge
this dynamite waiting
for a simultaneity
engendered by a
lost trajectory
that happened across
the track in time for
the sort of pounce
that wins converts
it is not the truth we're after
they may decide to say
to inspire more wiggling
and respiring
no determination

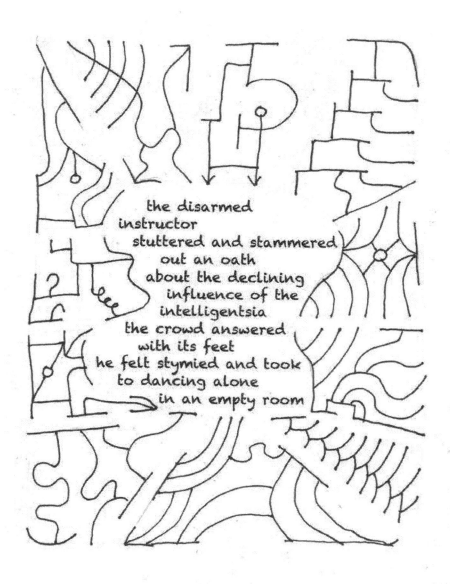

the disarmed
instructor
 stuttered and stammered
 out an oath
 about the declining
 influence of the
 intelligentsia
 the crowd answered
 with its feet
he felt stymied and took
to dancing alone
 in an empty room

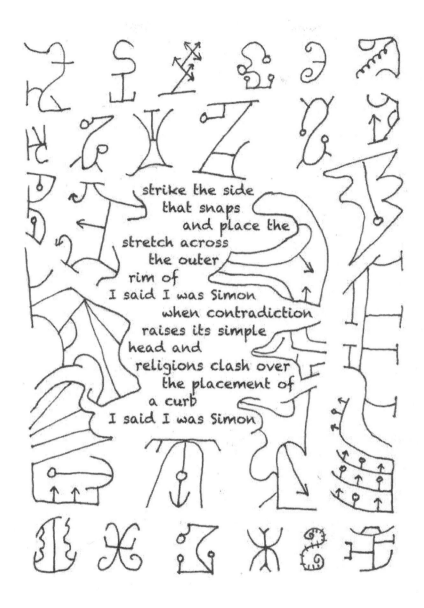

strike the side
that snaps
and place the
stretch across
the outer
rim of
I said I was Simon
when contradiction
raises its simple
head and
religions clash over
the placement of
a curb
I said I was Simon

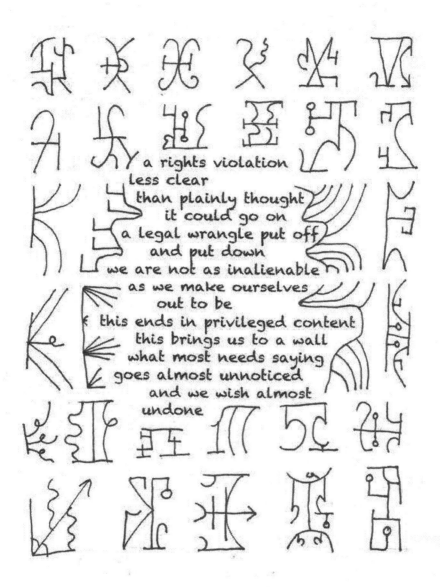

a rights violation
less clear
than plainly thought
it could go on
a legal wrangle put off
and put down
we are not as inalienable
as we make ourselves
out to be
this ends in privileged content
this brings us to a wall
what most needs saying
goes almost unnoticed
and we wish almost
undone

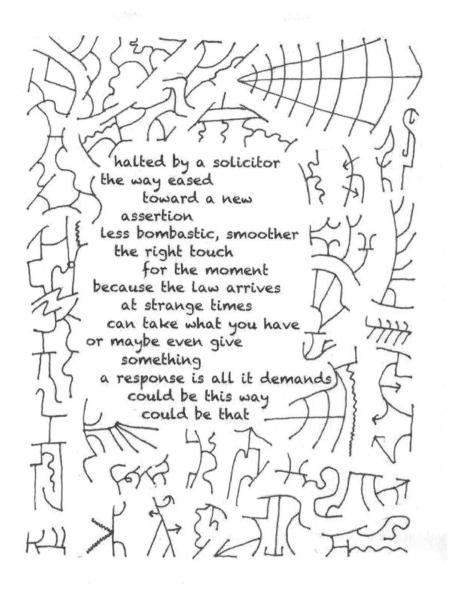

halted by a solicitor
the way eased
 toward a new
 assertion
 less bombastic, smoother
 the right touch
 for the moment
because the law arrives
 at strange times
 can take what you have
or maybe even give
 something
 a response is all it demands
 could be this way
 could be that

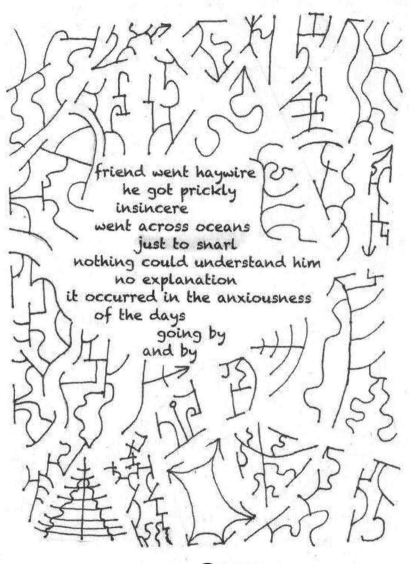

friend went haywire
he got prickly
insincere
went across oceans
just to snarl
nothing could understand him
no explanation
it occurred in the anxiousness
of the days
going by
and by

• about war?

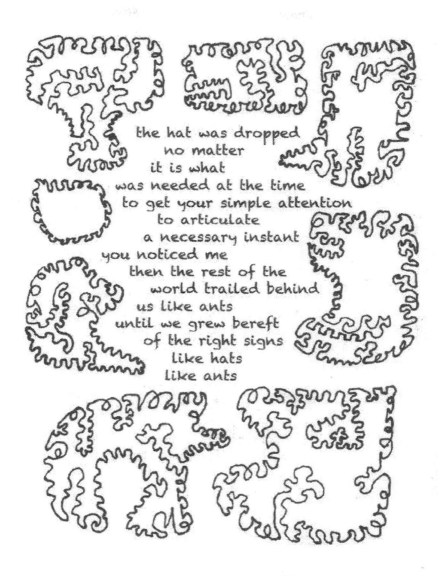

the hat was dropped
no matter
it is what
was needed at the time
to get your simple attention
to articulate
a necessary instant
you noticed me
then the rest of the
world trailed behind
us like ants
until we grew bereft
of the right signs
like hats
like ants

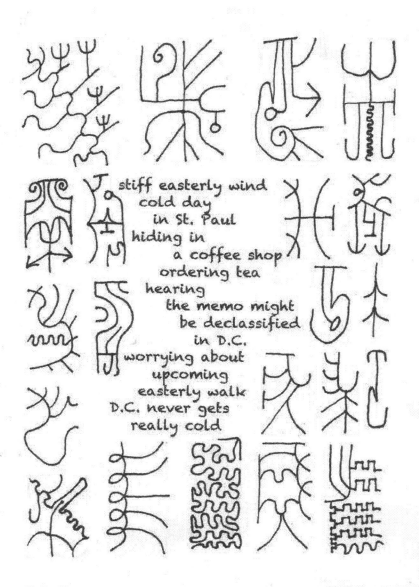

stiff easterly wind
cold day
 in St. Paul
hiding in
 a coffee shop
 ordering tea
hearing
 the memo might
 be declassified
 in D.C.
worrying about
 upcoming
 easterly walk
D.C. never gets
really cold

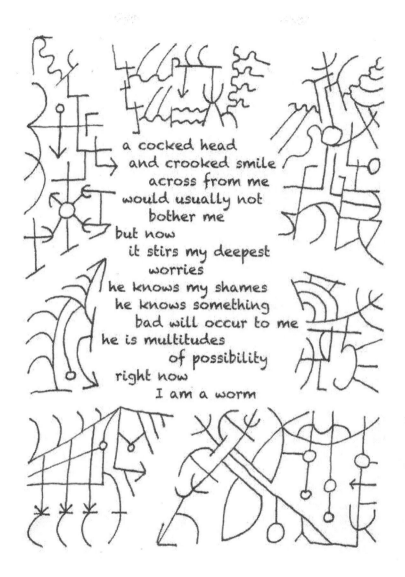

a cocked head
and crooked smile
across from me
would usually not
bother me
but now
it stirs my deepest
worries
he knows my shames
he knows something
bad will occur to me
he is multitudes
of possibility
right now
I am a worm

he shows himself forth
 from the last design
he is worth as much
 as he makes of himself
his wishes add up to
 a sprinkle and a little more
his imagination is limited
 to various boats and
 worries about people
 talking about him
he goes where he must
 according to his designs
very little holds him in place
 but it is plenty and wet
his name might as well
 be Don or, possibly, Mike
 but don't make it mean
he considers much
 and does even less
he likes to think he matters
 some, possibly to the cosmos
some say that his greatest
 contribution is to the atmosphere
most of this goes too far
 there must be a limit
he knows quite well

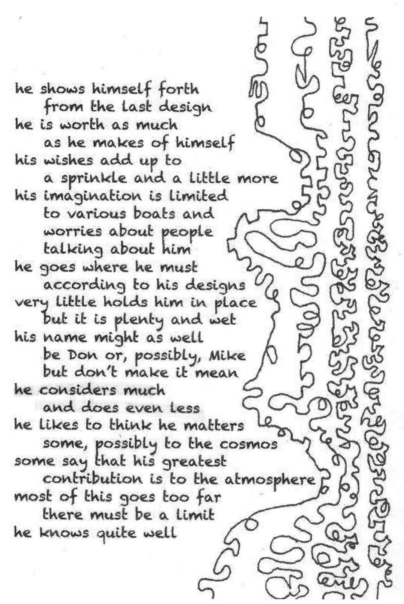

• About Depression and/or
 Anxiety?

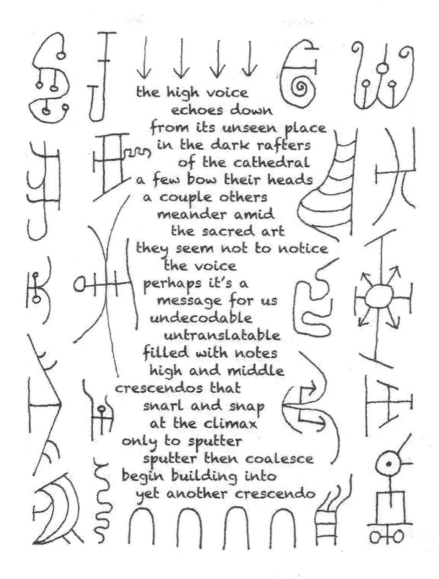

the high voice
echoes down
from its unseen place
in the dark rafters
of the cathedral
a few bow their heads
a couple others
meander amid
the sacred art
they seem not to notice
the voice
perhaps it's a
message for us
undecodable
untranslatable
filled with notes
high and middle
crescendos that
snarl and snap
at the climax
only to sputter
sputter then coalesce
begin building into
yet another crescendo

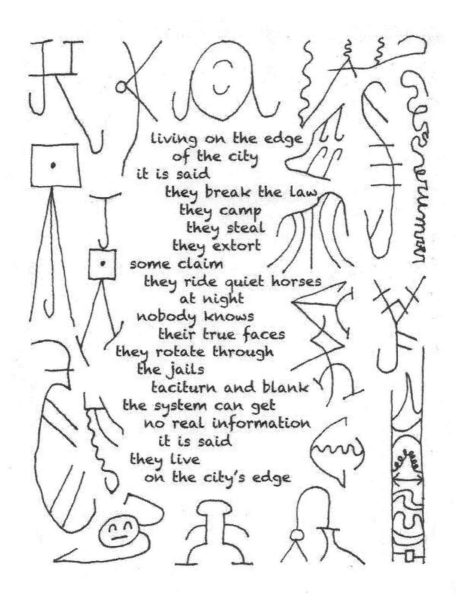

living on the edge
of the city
it is said
they break the law
they camp
they steal
they extort
some claim
they ride quiet horses
at night
nobody knows
their true faces
they rotate through
the jails
taciturn and blank
the system can get
no real information
it is said
they live
on the city's edge

walking a field
 past the limits
that you didn't
 know were there
dandelions
 yellow the ground
no people are around
 except for the
 armed guards
 you have learned
 to ignore
two move quickly
 towards you
 point their long
 guns at
 your feet
 and question hard
the sun is hot
 the guards
 do not seem
 to know how
 to smile
you ask them
 why they don't
 question the
 dandelions

•About Immigration?

39

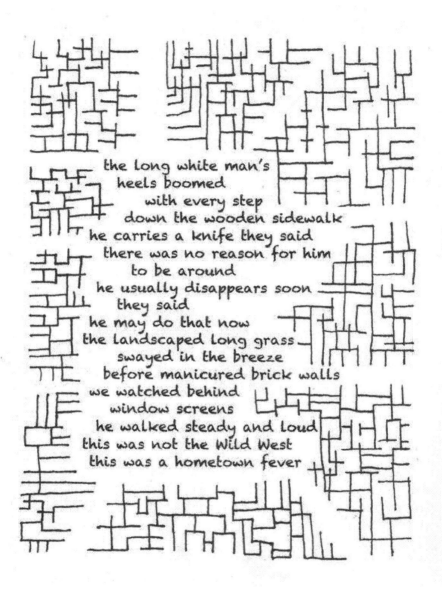

the long white man's
heels boomed
with every step
down the wooden sidewalk
he carries a knife they said
there was no reason for him
to be around
he usually disappears soon
they said
he may do that now
the landscaped long grass
swayed in the breeze
before manicured brick walls
we watched behind
window screens
he walked steady and loud
this was not the Wild West
this was a hometown fever

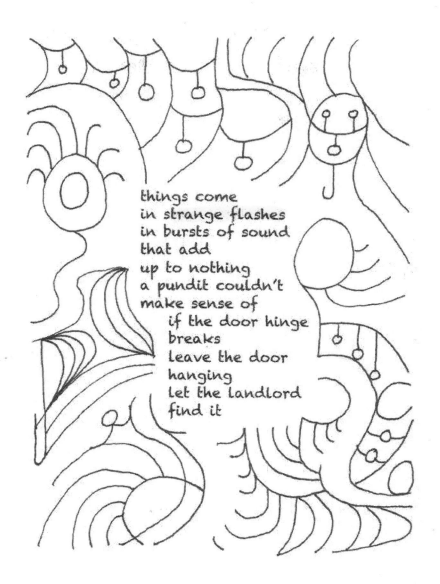

things come
in strange flashes
in bursts of sound
that add
up to nothing
a pundit couldn't
make sense of
 if the door hinge
 breaks
 leave the door
 hanging
 let the landlord
 find it

the lonely man
 conveys a specific
 stature in the world
 according to
 standard
 measurements
the ability to relearn
 may be limited
 self-awareness
 might not add up
 to enough
 the lonely man
 claims portions
 of land
 where he may
 or may not
 choose to live
loneliness doesn't make it
 to some people's
 awareness
 though they act
 on it often
 enough
 some claims
 properly filed
 can lead to house
 after house after
 condominium

lazy guesses
about the fate
of the timeworn
jester
who disappeared
with the spring
thaw
they were sick
of his jokes
Anyway

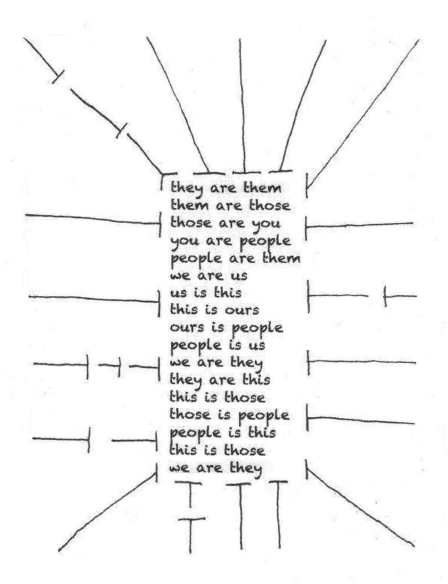

they are them
them are those
those are you
you are people
people are them
we are us
us is this
this is ours
ours is people
people is us
we are they
they are this
this is those
those is people
people is this
this is those
we are they

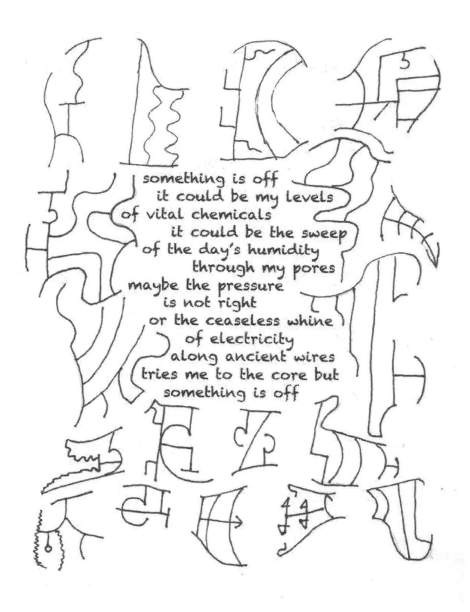

something is off
 it could be my levels
of vital chemicals
 it could be the sweep
of the day's humidity
 through my pores
maybe the pressure
 is not right
or the ceaseless whine
 of electricity
 along ancient wires
tries me to the core but
 something is off

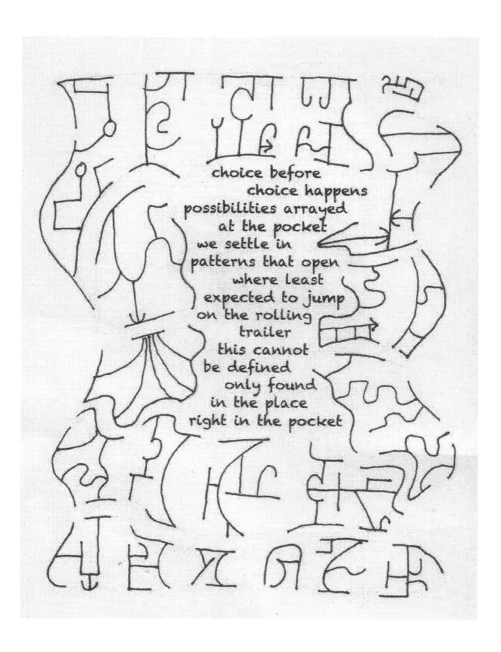

choice before
 choice happens
possibilities arrayed
 at the pocket
we settle in
patterns that open
 where least
 expected to jump
on the rolling
 trailer
 this cannot
be defined
 only found
in the place
right in the pocket

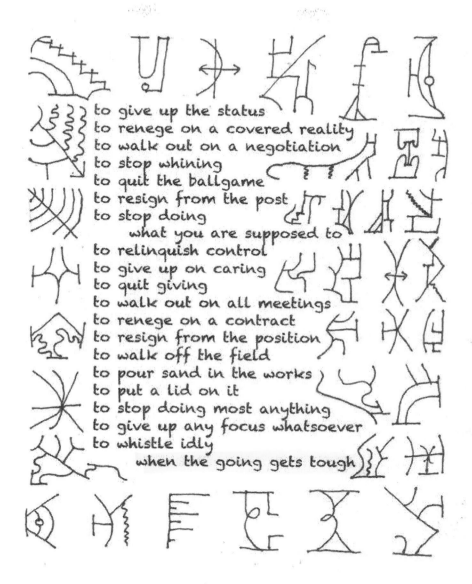

to give up the status
to renege on a covered reality
to walk out on a negotiation
to stop whining
to quit the ballgame
to resign from the post
to stop doing
 what you are supposed to
to relinquish control
to give up on caring
to quit giving
to walk out on all meetings
to renege on a contract
to resign from the position
to walk off the field
to pour sand in the works
to put a lid on it
to stop doing most anything
to give up any focus whatsoever
to whistle idly
 when the going gets tough

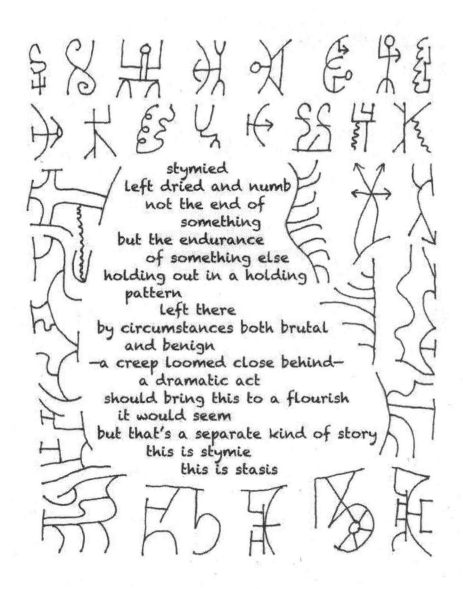

stymied
left dried and numb
not the end of
something
but the endurance
of something else
holding out in a holding
pattern
left there
by circumstances both brutal
and benign
—a creep loomed close behind—
a dramatic act
should bring this to a flourish
it would seem
but that's a separate kind of story
this is stymie
this is stasis

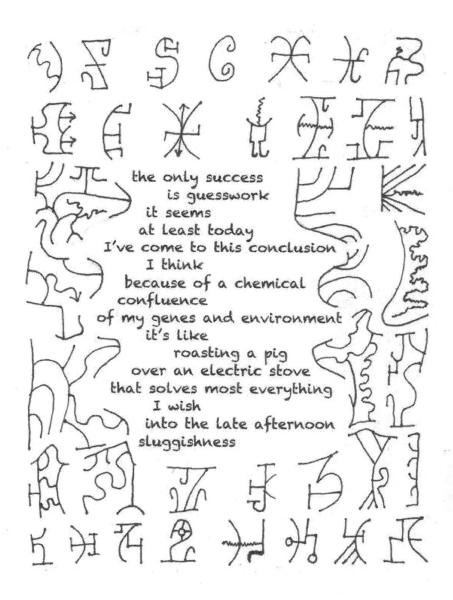

the only success
 is guesswork
 it seems
 at least today
I've come to this conclusion
 I think
 because of a chemical
 confluence
of my genes and environment
 it's like
 roasting a pig
 over an electric stove
 that solves most everything
 I wish
 into the late afternoon
 sluggishness

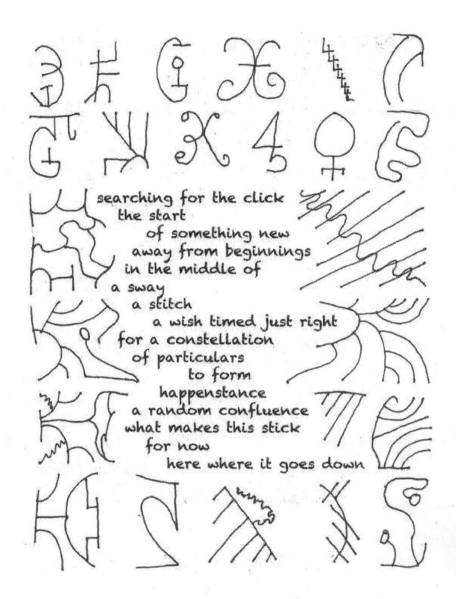

searching for the click
 the start
 of something new
 away from beginnings
 in the middle of
a sway
 a stitch
 a wish timed just right
 for a constellation
 of particulars
 to form
 happenstance
 a random confluence
what makes this stick
 for now
 here where it goes down

a loudness
torquing its way
down a winding
hallway
the sound
has no edge
no bottom
no top
it is a single
deep note
an eerie feeling
a vague déja vu
we all remember
some foggy time
when this same
sound accosted us
we listen wait
crouch down low
and it keeps
coming
nobody remembers
how it stopped
last time

stumbling more blindly
than knowing
 and the current turns
suddenly
as if gravity itself switched
 to a new rhythm
 this will hold out until
 the tensions give way
 left out
 left over

if he couldn't but would
 this chance
 attack coming from a lateral
quarter demanding and insisting
 some sort of understanding
 less specific than what
we could over the quarter
 of wish develop a specific
 alternative to give that sheen
 they come at us at
 the strangest times
 in short, I never know
 what's gonna
 hit me 'round here
 but even that is a lie in its
 shortness its lack of fluidity
its sizing things up too suddenly

voices from another
section of the building
seemed clipped
 anxious but
I can't make out the
 substance of what
 they say
 this is my spot, now,
to wonder what is
 being said
what importance it may usher
while I am alone
 to stay here
in accordance with
 definite demands
 unbending for now

I am always visible
 all I do is filmed
there are cameras
in the walls
 of my apartment
someone monitors
 them
there are cameras
 on the telephone
 poles outside
someone monitors
 them
I am watched
 wherever I go
I have no secrets
 I am always visible

55

after all the attempts
of the day
have gone down
for good, for ill
for just getting them done
a gloom may
color the trees
the road, the buildings
a dull grey stasis
and you wonder if
you will be stuck
in the grey forever
that you will never
be yourself again
this may go on for years
but most likely
you will eventually
get your colors back
and the trees
will be green
the road black
and you will be startled
several afternoons
at the vibrancy
of it all

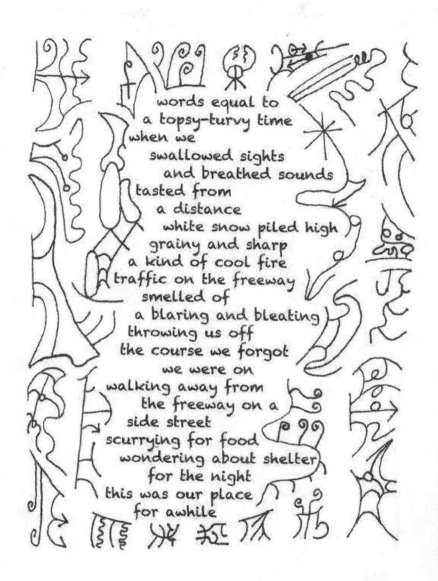

words equal to
a topsy-turvy time
when we
swallowed sights
and breathed sounds
tasted from
a distance
white snow piled high
grainy and sharp
a kind of cool fire
traffic on the freeway
smelled of
a blaring and bleating
throwing us off
the course we forgot
we were on
walking away from
the freeway on a
side street
scurrying for food
wondering about shelter
for the night
this was our place
for awhile

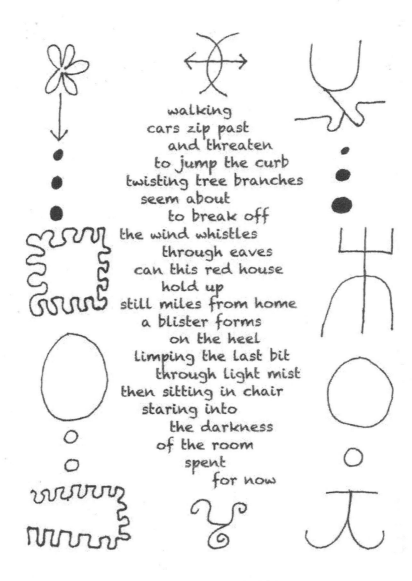

walking
cars zip past
and threaten
to jump the curb
twisting tree branches
seem about
to break off
the wind whistles
through eaves
can this red house
hold up
still miles from home
a blister forms
on the heel
limping the last bit
through light mist
then sitting in chair
staring into
the darkness
of the room
spent
for now

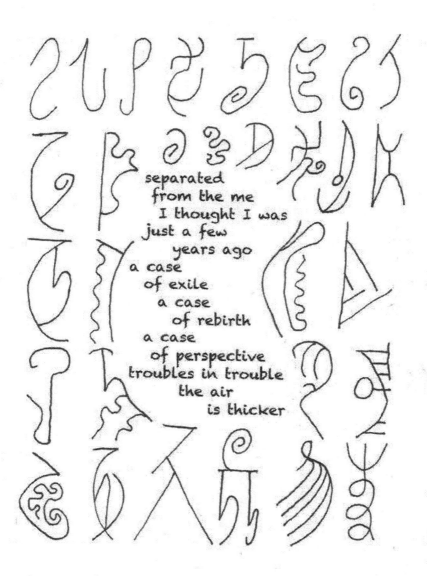

separated
 from the me
 I thought I was
just a few
 years ago
a case
 of exile
 a case
 of rebirth
a case
 of perspective
troubles in trouble
 the air
 is thicker

59

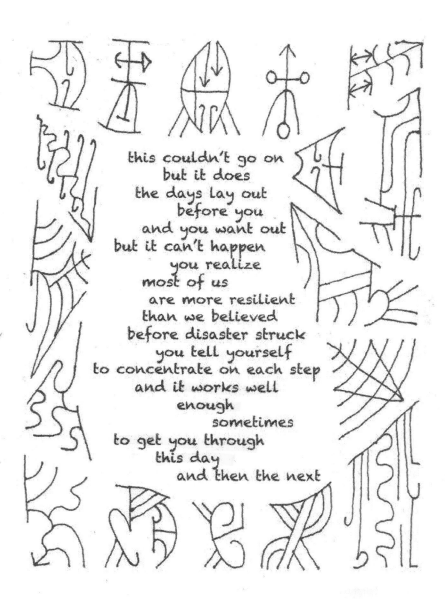

this couldn't go on
but it does
the days lay out
before you
and you want out
but it can't happen
you realize
most of us
are more resilient
than we believed
before disaster struck
you tell yourself
to concentrate on each step
and it works well
enough
sometimes
to get you through
this day
and then the next

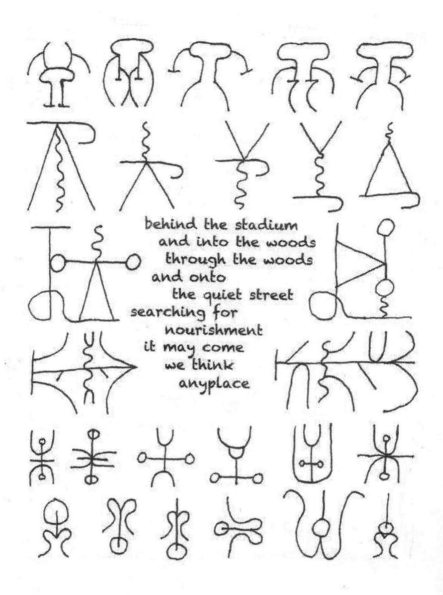

behind the stadium
and into the woods
through the woods
and onto
the quiet street
searching for
nourishment
it may come
we think
anyplace

61

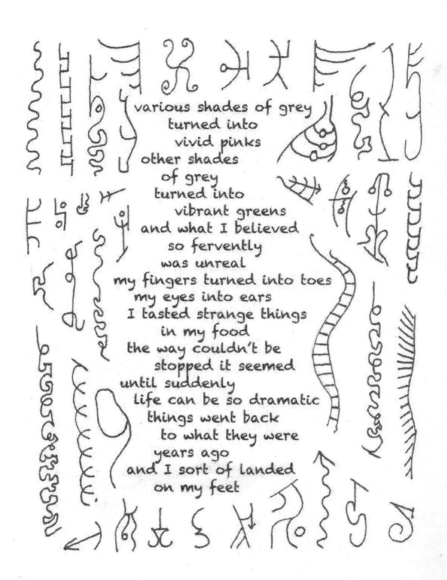

various shades of grey
 turned into
 vivid pinks
other shades
 of grey
 turned into
 vibrant greens
and what I believed
 so fervently
 was unreal
my fingers turned into toes
 my eyes into ears
 I tasted strange things
 in my food
the way couldn't be
 stopped it seemed
until suddenly
 life can be so dramatic
 things went back
 to what they were
 years ago
and I sort of landed
 on my feet

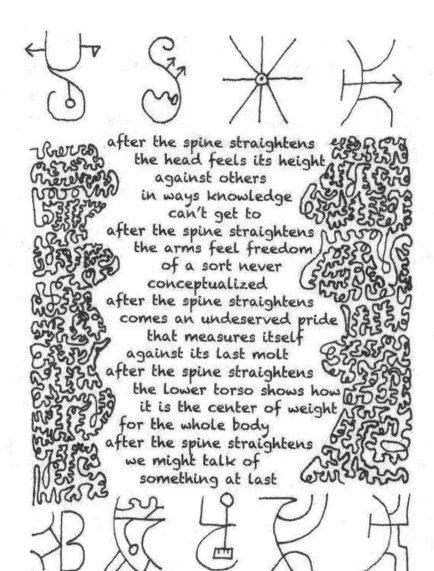

after the spine straightens
the head feels its height
against others
in ways knowledge
can't get to
after the spine straightens
the arms feel freedom
of a sort never
conceptualized
after the spine straightens
comes an undeserved pride
that measures itself
against its last molt
after the spine straightens
the lower torso shows how
it is the center of weight
for the whole body
after the spine straightens
we might talk of
something at last

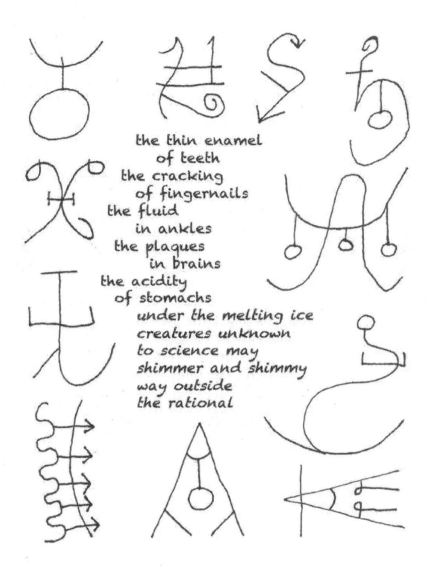

the thin enamel
 of teeth
 the cracking
 of fingernails
 the fluid
 in ankles
 the plaques
 in brains
 the acidity
 of stomachs
 under the melting ice
 creatures unknown
 to science may
 shimmer and shimmy
 way outside
 the rational

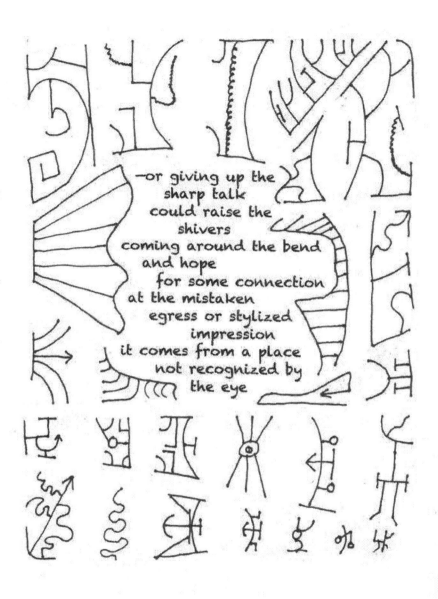

—or giving up the
sharp talk
could raise the
shivers
coming around the bend
and hope
for some connection
at the mistaken
egress or stylized
impression
it comes from a place
not recognized by
the eye

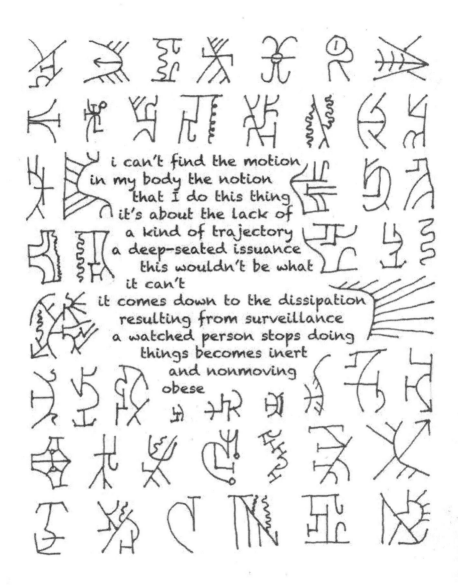

i can't find the motion
in my body the notion
that I do this thing
it's about the lack of
a kind of trajectory
a deep-seated issuance
this wouldn't be what
it can't
it comes down to the dissipation
resulting from surveillance
a watched person stops doing
things becomes inert
and nonmoving
obese

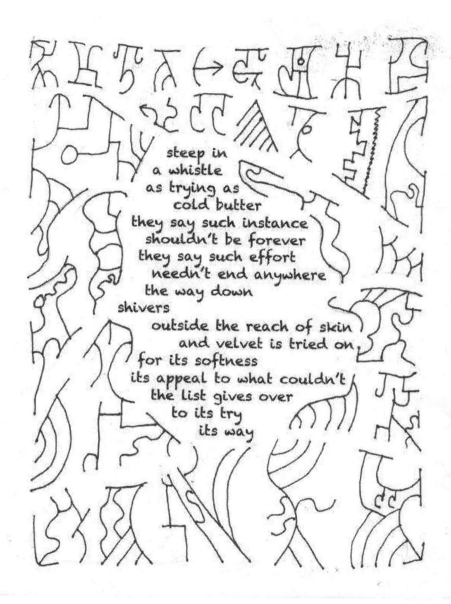

steep in
a whistle
as trying as
cold butter
they say such instance
shouldn't be forever
they say such effort
needn't end anywhere
the way down
shivers
outside the reach of skin
and velvet is tried on
for its softness
its appeal to what couldn't
the list gives over
to its try
its way

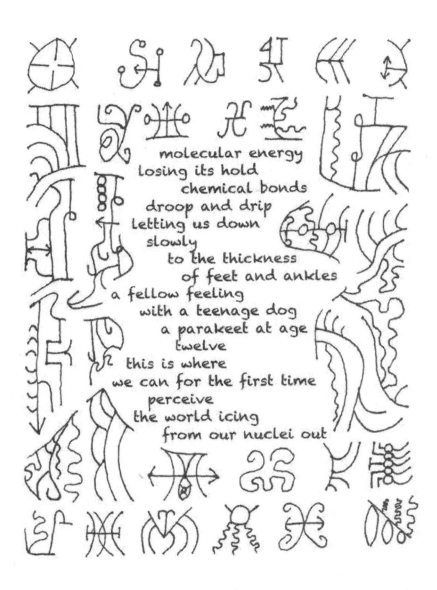

molecular energy
losing its hold
 chemical bonds
droop and drip
letting us down
 slowly
 to the thickness
 of feet and ankles
a fellow feeling
 with a teenage dog
 a parakeet at age
 twelve
 this is where
we can for the first time
 perceive
the world icing
 from our nuclei out

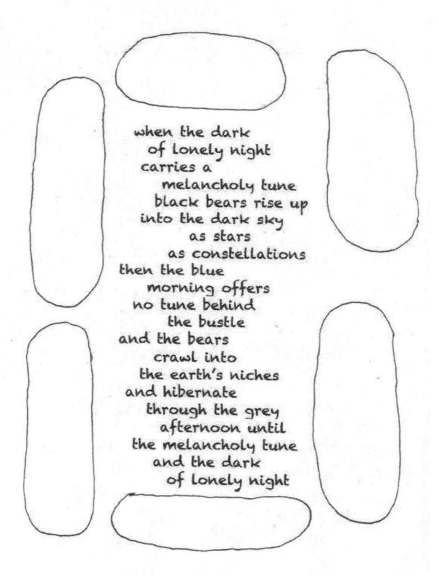

when the dark
 of lonely night
carries a
 melancholy tune
 black bears rise up
into the dark sky
 as stars
 as constellations
then the blue
 morning offers
no tune behind
 the bustle
and the bears
 crawl into
 the earth's niches
and hibernate
 through the grey
 afternoon until
the melancholy tune
 and the dark
 of lonely night

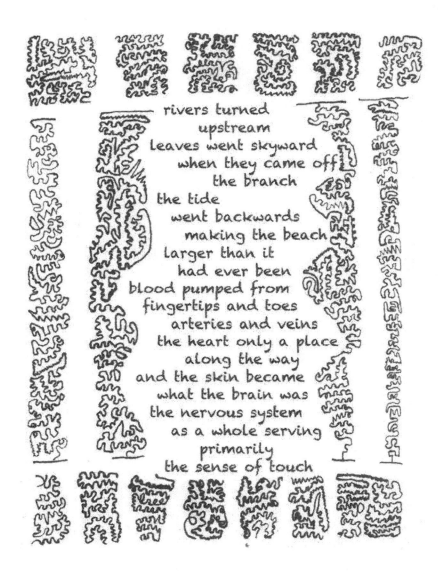

rivers turned
upstream
leaves went skyward
when they came off
the branch
the tide
went backwards
making the beach
larger than it
had ever been
blood pumped from
fingertips and toes
arteries and veins
the heart only a place
along the way
and the skin became
what the brain was
the nervous system
as a whole serving
primarily
the sense of touch

70

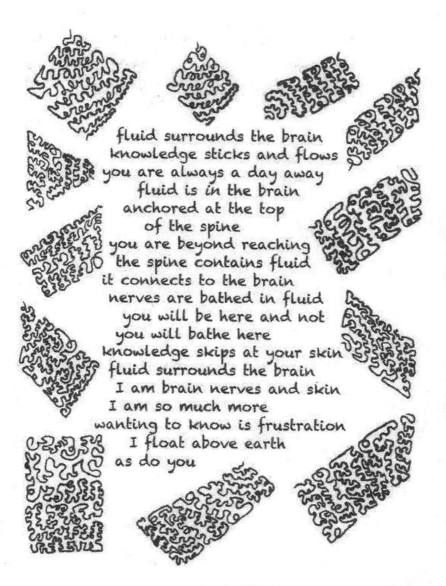

fluid surrounds the brain
knowledge sticks and flows
you are always a day away
 fluid is in the brain
 anchored at the top
 of the spine
you are beyond reaching
 the spine contains fluid
it connects to the brain
 nerves are bathed in fluid
 you will be here and not
 you will bathe here
knowledge skips at your skin
 fluid surrounds the brain
 I am brain nerves and skin
 I am so much more
wanting to know is frustration
 I float above earth
 as do you

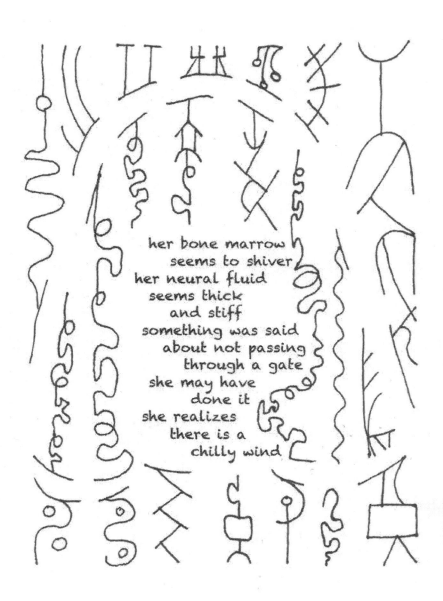

her bone marrow
 seems to shiver
her neural fluid
 seems thick
 and stiff
something was said
 about not passing
 through a gate
she may have
 done it
she realizes
 there is a
 chilly wind

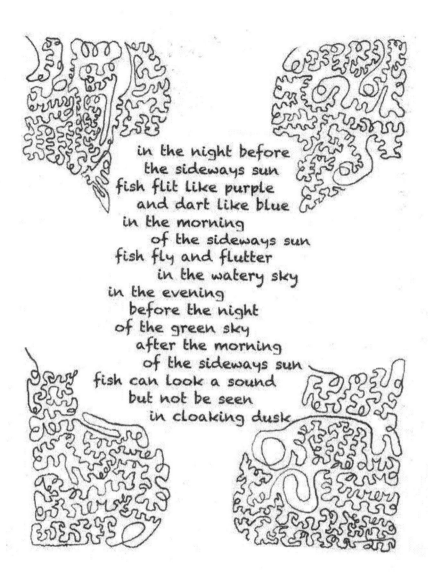

in the night before
the sideways sun
fish flit like purple
and dart like blue
in the morning
of the sideways sun
fish fly and flutter
in the watery sky
in the evening
before the night
of the green sky
after the morning
of the sideways sun
fish can look a sound
but not be seen
in cloaking dusk

here the day does not
 turn to night
 the day turns
 to another day
 like the previous
 there is no darkness
 there is no sleep
 people come home
 from work
 they eat
 stand guard
 at the window
 as the sun ends its
 circle in the sky
 it's back to work
 some say you die
 without sleeping
 but here they are wrong
 it is perpetually summer
 the rains come every
 thursday afternoon
 it feels as if
 all is alert always
 waiting for something

the sparrows
arrived
in time
for your
unscheduled
investiture
your rude
graciousness
your silly formality
jolly and jostling
stretching their
way on

the Chittenden and
Eastman building
has been divvied
up into lofts
skeletons live there
they need not eat
or drink because
bone and its dried
marrow are their
own nutrients
the pockmarked moon
comes down
every morning
to join them
skulls and the moon
are made of
a special type
of chalk
they write simple
evocative stories
of the night
on boards all morning
at night
more chalk comes
to them to take
the place
of that used
on blackboards

76

the afternoon
moon gets tired
of the blue sky
it shrinks
and floats down
to a little boy
chasing black flies
in a dusty
backyard
the moon rests
on his right shoulder
the boy wonders
aloud why the
moon came down
the moon
doesn't answer
sits on his shoulder
then floats away
and the tides
stopped in
their tracks
coral stopped
spawning
the earth
spun faster
because the moon
didn't like blue

under the orange moon
little mammals come out
they steal into homes
while the world sleeps
empty the produce
from the 'frig'
put it in canvas bags
where they go to eat
nobody knows

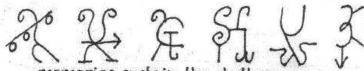

memories sustain the rhythms
of the way the earth turns
just here to make the sun
shine through the slits of
trees across the lake
almost the same way each day
memories of walking the path
to the small manmade beach
where the rowboat waits for fishing
lake trout to be eaten that night
the earth has a small
gravitational effect on the sun
as do the other planets
causing it to move in small ovals
the birds here call in squawks
tweets and song
blue jay sparrow cardinal
and flit from oak branch
to oak branch in neighboring trees
their instinct perhaps
a kind of memory
more powerful than noticing

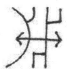 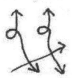 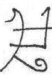

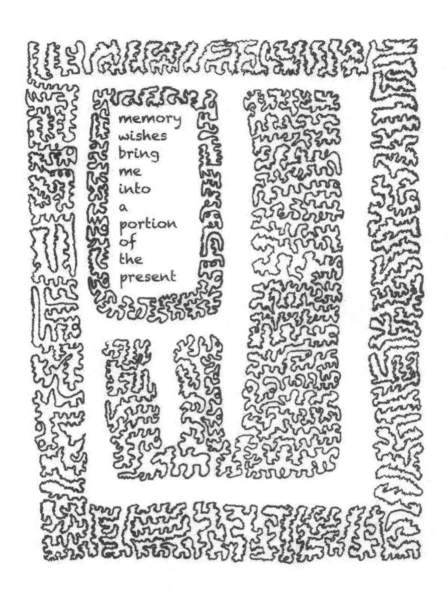

memory
wishes
bring
me
into
a
portion
of
the
present

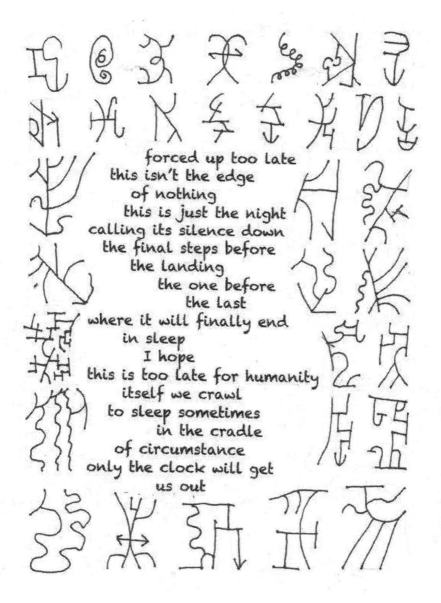

forced up too late
this isn't the edge
of nothing
this is just the night
calling its silence down
the final steps before
the landing
the one before
the last
where it will finally end
in sleep
I hope
this is too late for humanity
itself we crawl
to sleep sometimes
in the cradle
of circumstance
only the clock will get
us out

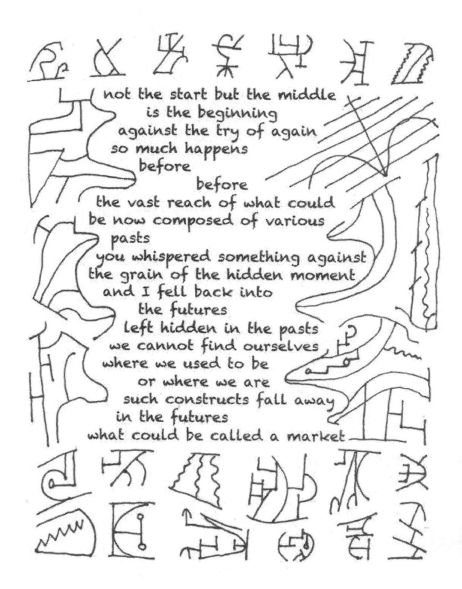

not the start but the middle
is the beginning
against the try of again
so much happens
before
before
the vast reach of what could
be now composed of various
pasts
you whispered something against
the grain of the hidden moment
and I fell back into
the futures
left hidden in the pasts
we cannot find ourselves
where we used to be
or where we are
such constructs fall away
in the futures
what could be called a market

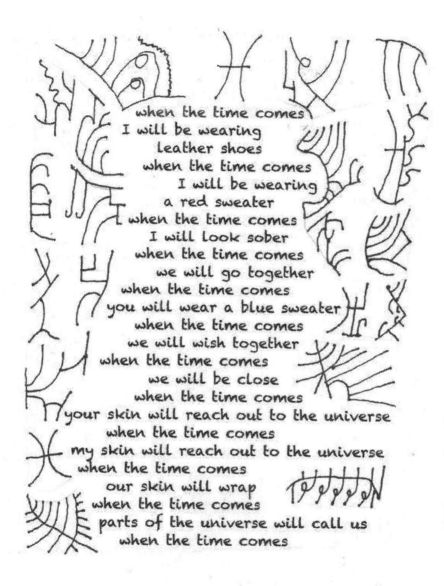

when the time comes
I will be wearing
leather shoes
when the time comes
I will be wearing
a red sweater
when the time comes
I will look sober
when the time comes
we will go together
when the time comes
you will wear a blue sweater
when the time comes
we will wish together
when the time comes
we will be close
when the time comes
your skin will reach out to the universe
when the time comes
my skin will reach out to the universe
when the time comes
our skin will wrap
when the time comes
parts of the universe will call us
when the time comes

it could start again
around the bend
in the road
it is where smugglers
for years have hidden
and where distracted
drivers lose control
crosses mark the spots
of death
you could say
there is little that stands
out in this insistence
other than a need
to begin
and begin again
after even a moment's
hesitation

the lesson comes too soon
to matter much
we won't need its
information until
we have forgotten it
when the moment comes
there isn't
time for relearning
we're backed up and clogged
rocks seem living
full of fluids and
processes
even brick buildings pulse
with an unknown force
we vaguely remember
we were
once taught
what to do
but it's too late
for that now

while the main media outlets
looked around and went
beserk
we talked our way through
a night of funky smells
and yellow sounds
a green and red
texture holding us
this morning
warp and woof
even in the flesh
where there is no going
elsewhere
just forgetting

ice at the edge
of the lake
becomes thin
translucent
the water underneath
quiet
 waiting
the next day
an April blizzard
buries all signs
of warmth
but the memory remains
of what this day
should have been
according to all
instituted norms

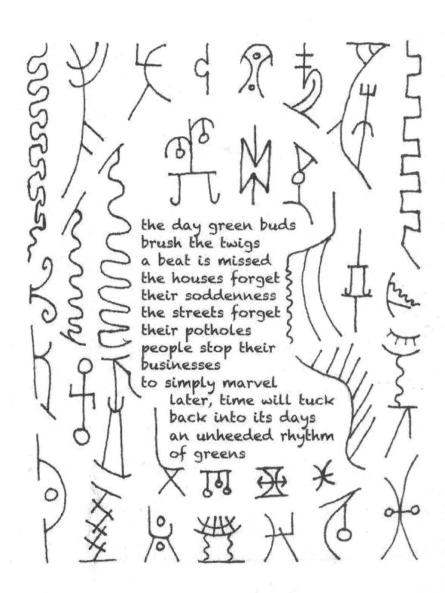

the day green buds
brush the twigs
a beat is missed
the houses forget
their soddenness
the streets forget
their potholes
people stop their
businesses
to simply marvel
 later, time will tuck
 back into its days
 an unheeded rhythm
 of greens

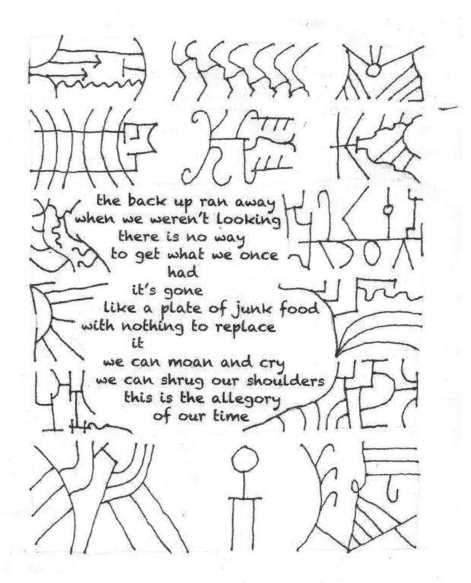

the back up ran away
when we weren't looking
there is no way
to get what we once
had
it's gone
like a plate of junk food
with nothing to replace
it
we can moan and cry
we can shrug our shoulders
this is the allegory
of our time

I feel icky
the radiator's
 sprung a leak
the trail is
 closed for winter
the snow
 in parking lots
 is pushed
 way into the street
we could try
 to get away
we could get nicer
 but it takes
 all our time
better to pick
 and prod let
the devil come out
 to the icky dance
something aims
 at us

clouds came
and darkness fell there
is no reason for
the loss of shoes
given the state of the
market
said the analyst
to no one in particular
we are on top of
a new way
to mortgage the status
of humdingers
and retrograde stuffed
prairie dogs
said the confused police
officer
at the end of another demanding day

what wouldn't
in the coming down
find something to like
on the way
like a soaring hawk
wings spread
the tops of trees
bushing out
or a goldfinch
hiding in a tree
what wouldn't
in the coming down
find something to dislike
as the fear
of crashing
or the wind blowing
the falling face back
or the vulture
you see
circling above
after you land

without
the wind of a reason
aimed in a particular
direction
started walking
like a root
tripping its way
toward water
it thinks
in its way

in forgetting my stance
I may sense
the pulse in the flittings
of awareness
when I feel what
seems my inevitable
winding course
I rustle with leaves
I tumble downstream
I stretch through soil
like a rhizome
I forget even myself
into this pulse
where I find not exactly
a second self
but a connection
to processes
I belong to
but rarely notice

94

time thickens
he wades through
the grey haze
head down
just moving
time thickens
and he wonders
what gives
the dawn back
to itself
time thickens
and the lightning
opens the layers
of the grey
the clouds flowing
time thickens
thunder echoes through
the haze
where is the rain
could it wash this
away
time thickens
until it gives way
to a new rhythm
and sunlight bounces
off windows and siding

at the neighborhood bar
with friends
spectacle tonight
a band, silly hats
people playing pool
cheering
outside it is 10 below
without wind chill
the snow is grey
I walk alone
a mile home
past other bars
restaurants
all sealed tightly
against the cold
and keeping
the sounds in
buildings are small
below the
black sky
cold reaches up
to the unseen clouds
and beyond
I meet one
other walker
we do not greet
each other
it is New Year's Eve

rocks crack
and fissure
 beneath the city
 above the mantle
a drama may
 take generations
to emerge
into view
the city's buildings
 embedded in soil
 and little rocks
 over generations
crack and crumble
 at the foundation
dramas can be
 fires bursting up
 from below

this could be the sound
of guessing what
sounds could be
or maybe it has to do
with the motion of the arm
how the shoulder socket
whispers to itself
this is the way sound is made
the body touching both
itself and the outside
across the alley
and against the meridian
a kid bangs on a bucket
with a hard stick

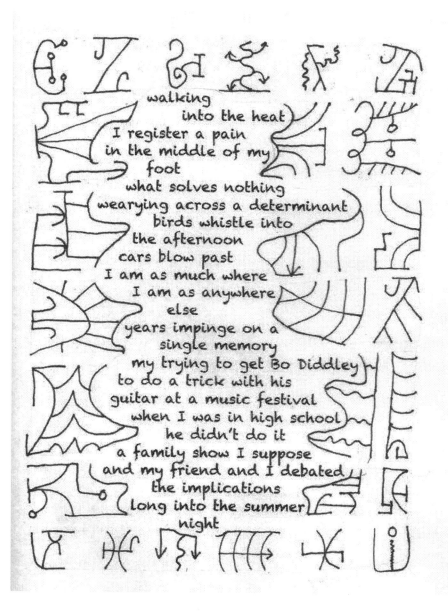

walking
 into the heat
I register a pain
in the middle of my
 foot
what solves nothing
wearying across a determinant
 birds whistle into
the afternoon
cars blow past
I am as much where
 I am as anywhere
 else
years impinge on a
 single memory
 my trying to get Bo Diddley
to do a trick with his
guitar at a music festival
 when I was in high school
 he didn't do it
 a family show I suppose
and my friend and I debated
 the implications
 long into the summer
 night

softer than
the growth of hair
the molting of skin
to dust
softer still
softer than a caress
downward on a beard
a dropping fleck
in front of the eyes
a flit of consciousness
softer than
a coo in an ear
a caress of the temple
a cotton shirt falling on
softer than
whistling at dawn
taking a stroll
whispering silliness
softer than softness
plant animal human

Jefferson Hansen lives in Minneapolis and is the author of the selected poems *Jazz Forms*, the novel *And Beefheart Saved Craig*, and the short story collection *Cruelty*.

Made in the USA
San Bernardino, CA
10 January 2020

63018453R00062